MODERN TATTuu
DESIGNS
COLORING BOOK

ERIK SIUDA

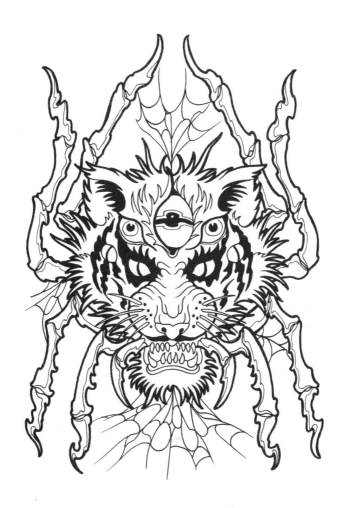

DOVER PUBLICATIONS, INC.
MINEOLA, NEW YORK

NOTE

The thirty-one finely detailed and ready-to-color illustrations found inside this book depict elaborate body art motifs. A unique source of inspiration for artists interested in tattoo design, the images inside feature floral, animal, and fantasy patterns, plus a host of others. Perforated pages make it easy to display your work when you're done coloring.

Copyright
Copyright © 2013 by Dover Publications, Inc.
All rights reserved.

Bibliographical Note
Modern Tattoo Designs is a new work, first published by Dover Publications, Inc., in 2013.

International Standard Book Number
ISBN-13: 978-0-486-49326-8
ISBN-10: 0-486-49326-1

Manufactured in the United States by RR Donnelley
49326108 2015
www.doverpublications.com

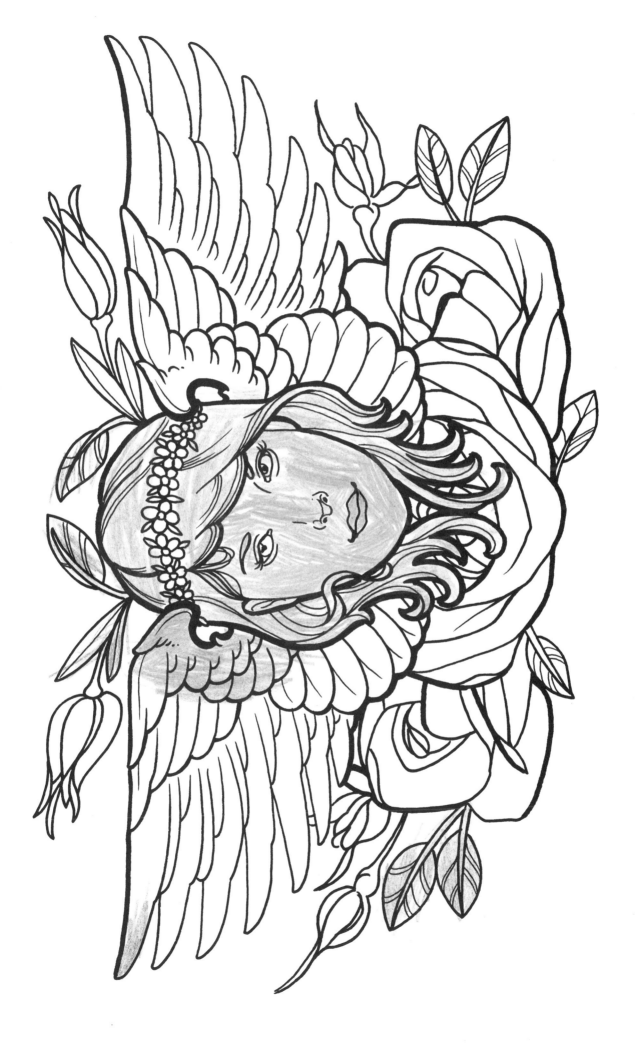

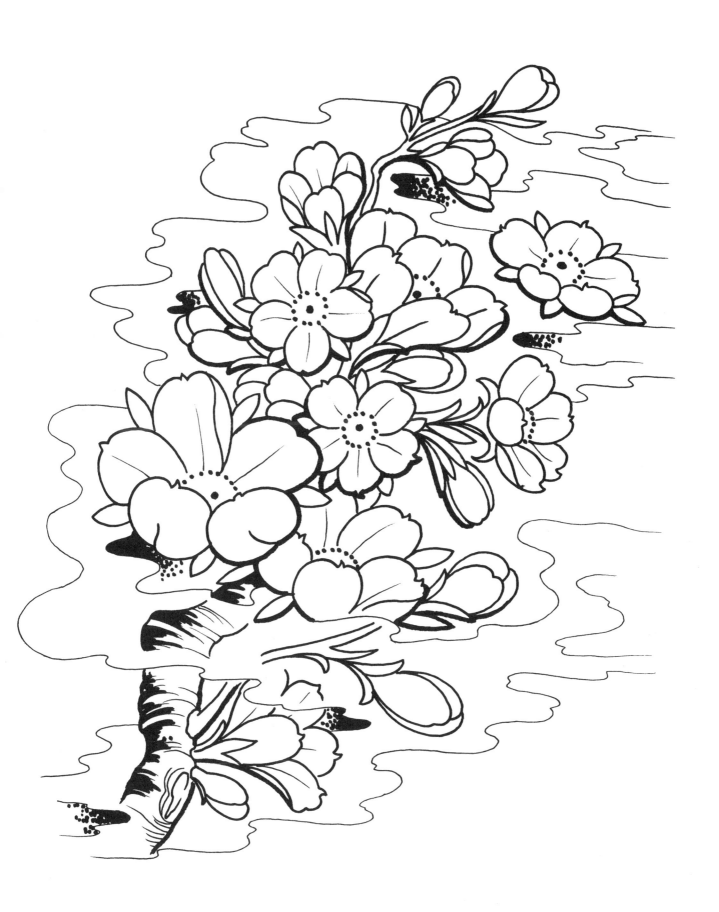

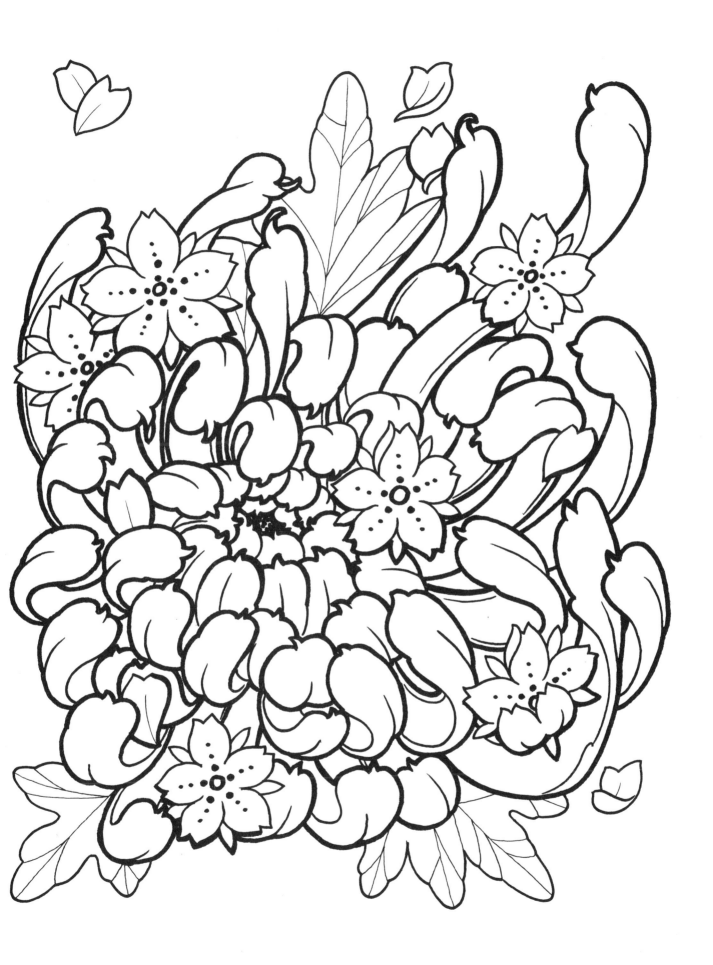

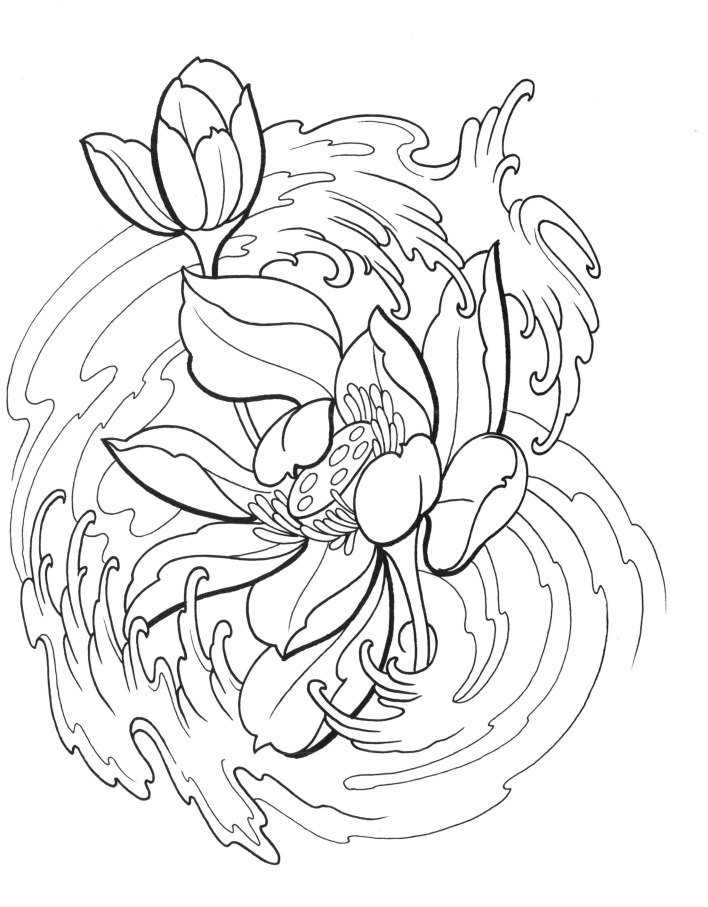

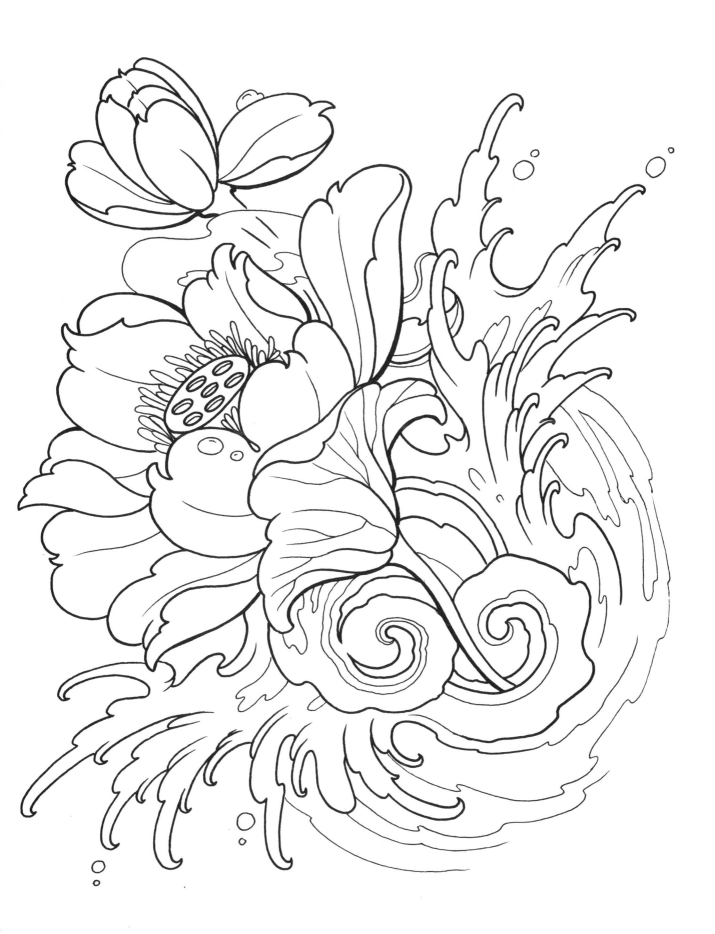

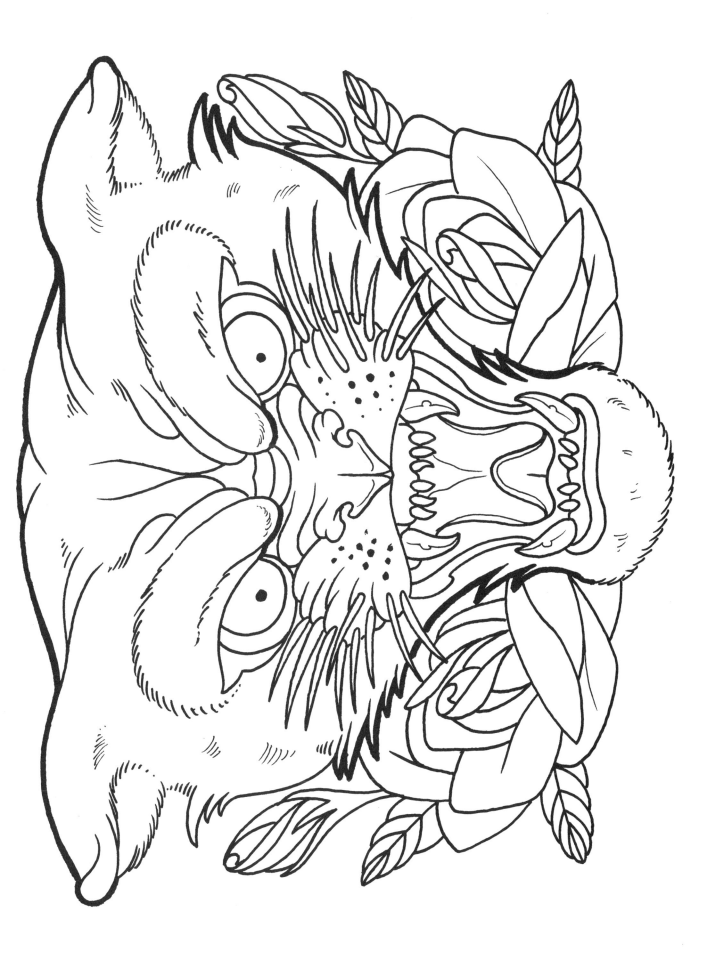

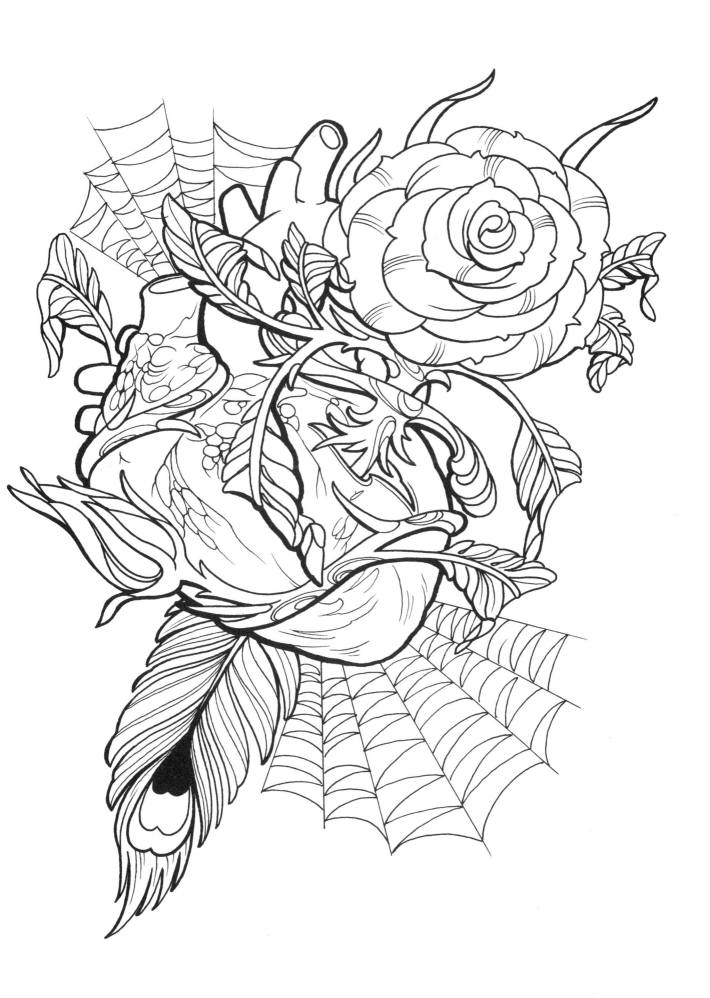

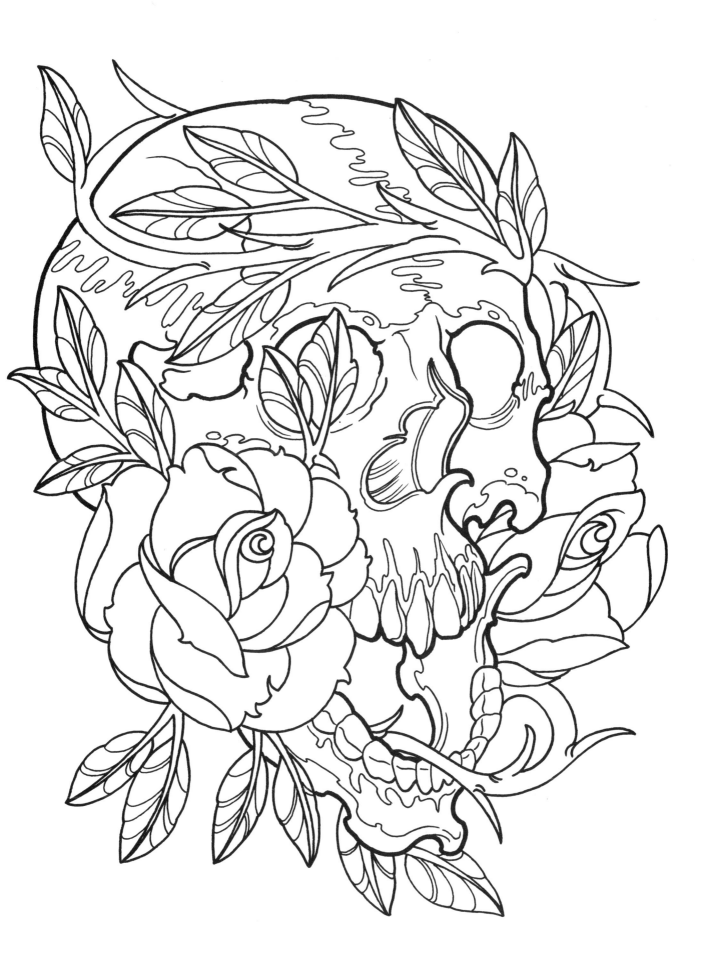

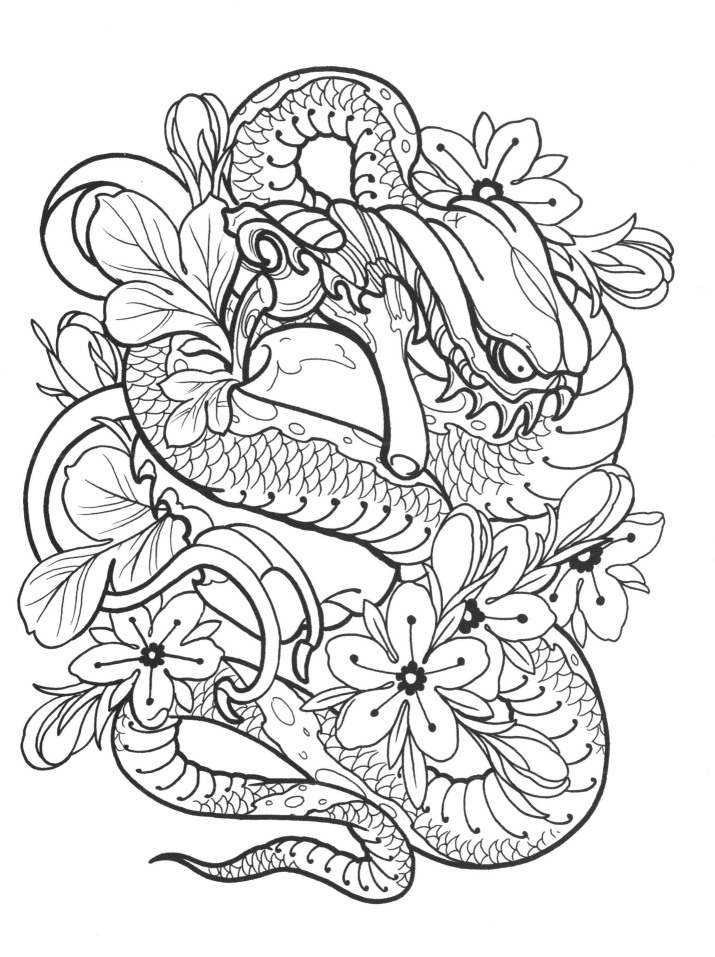

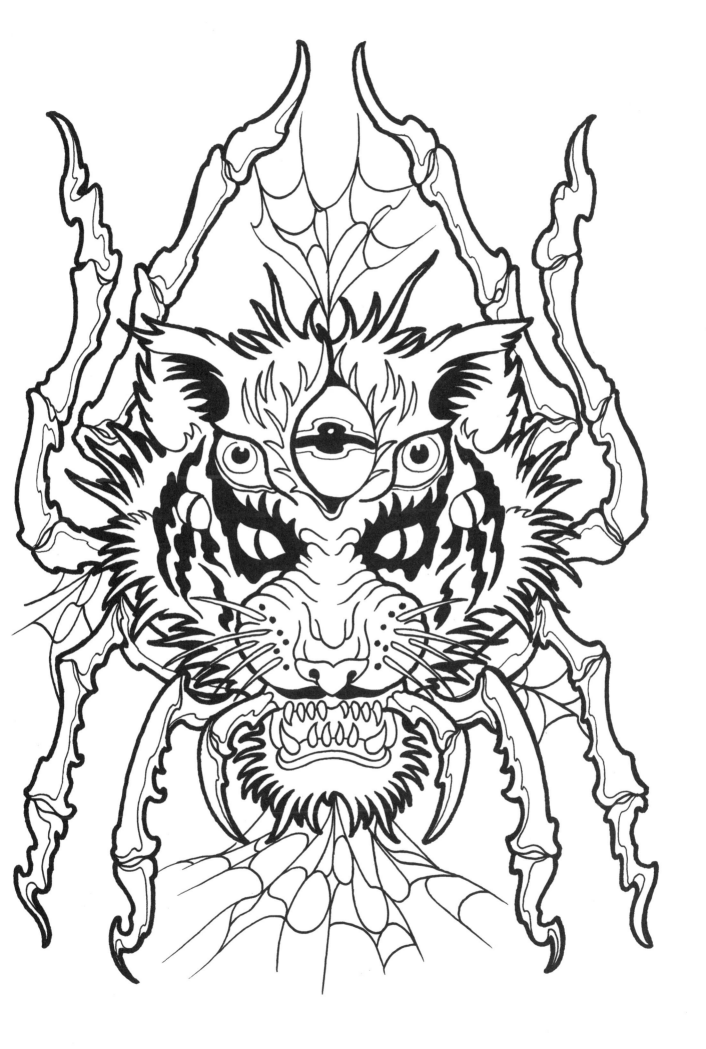

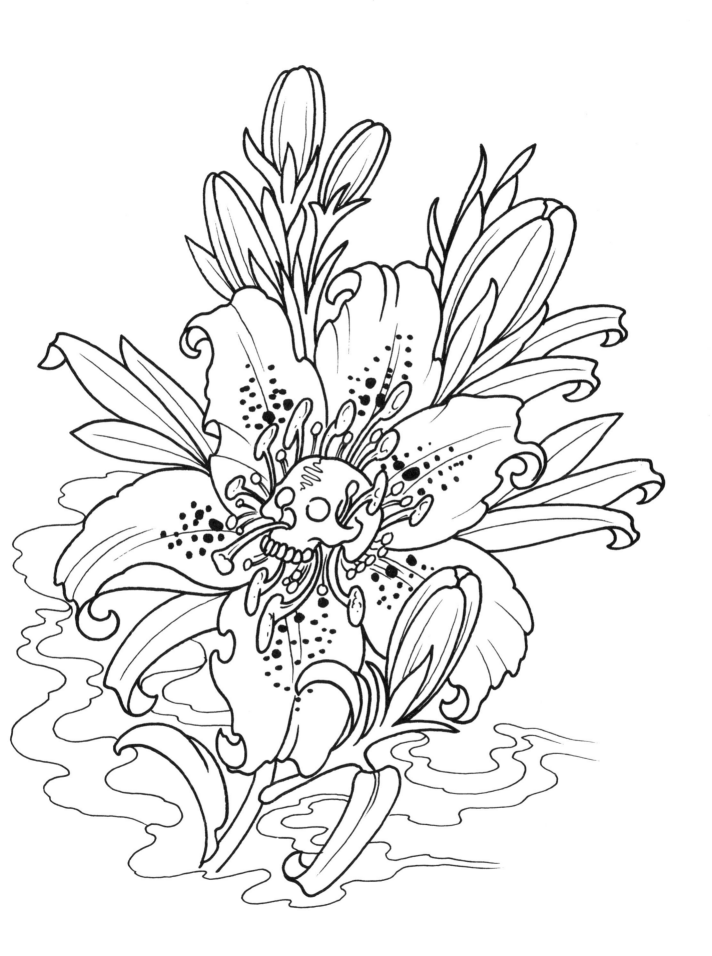

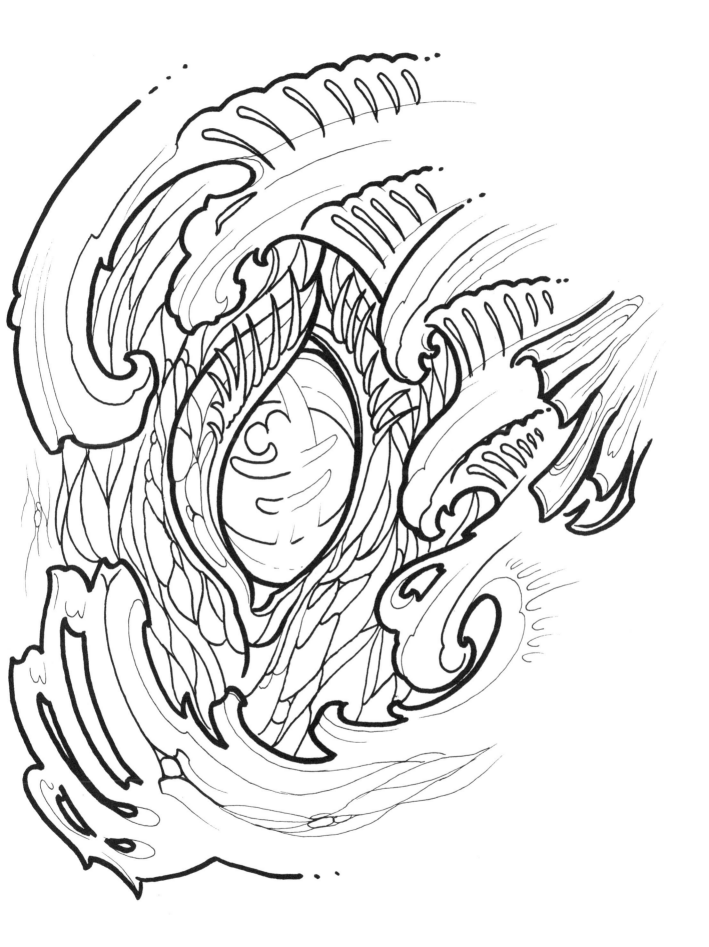

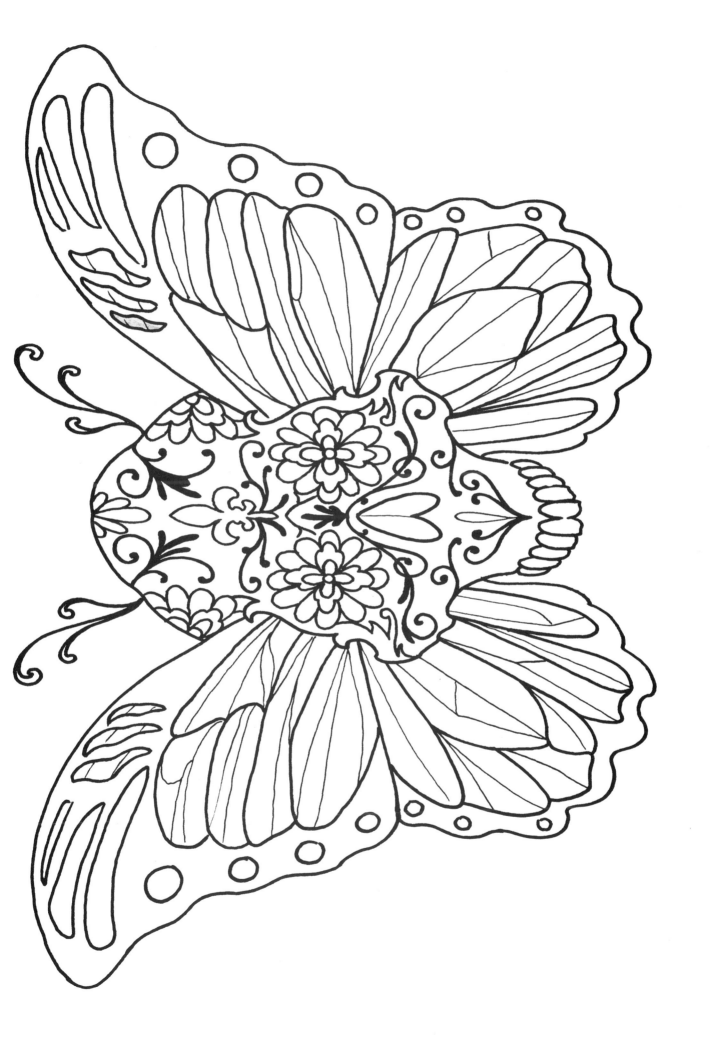

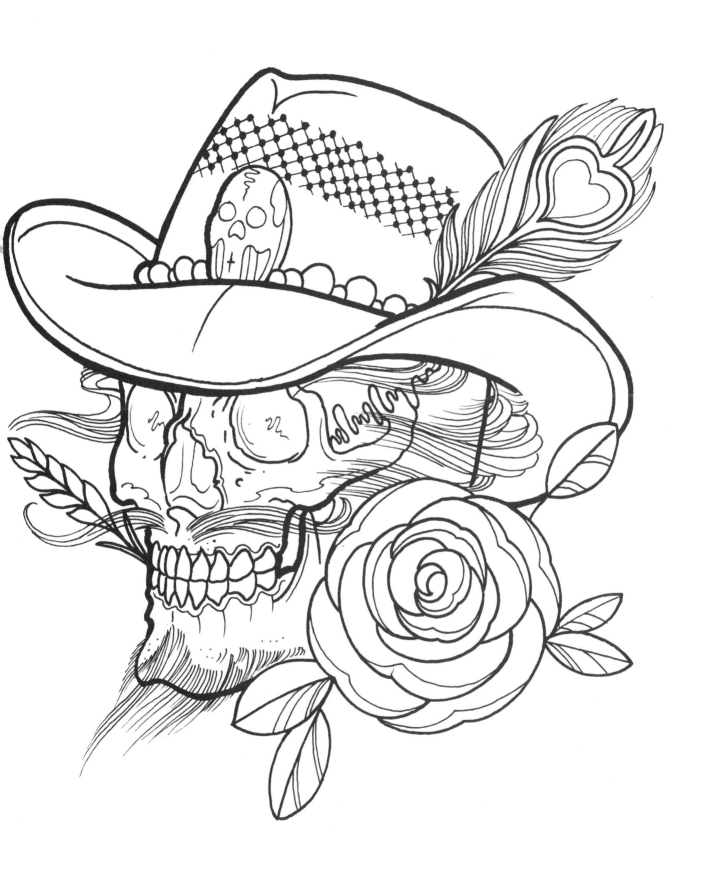

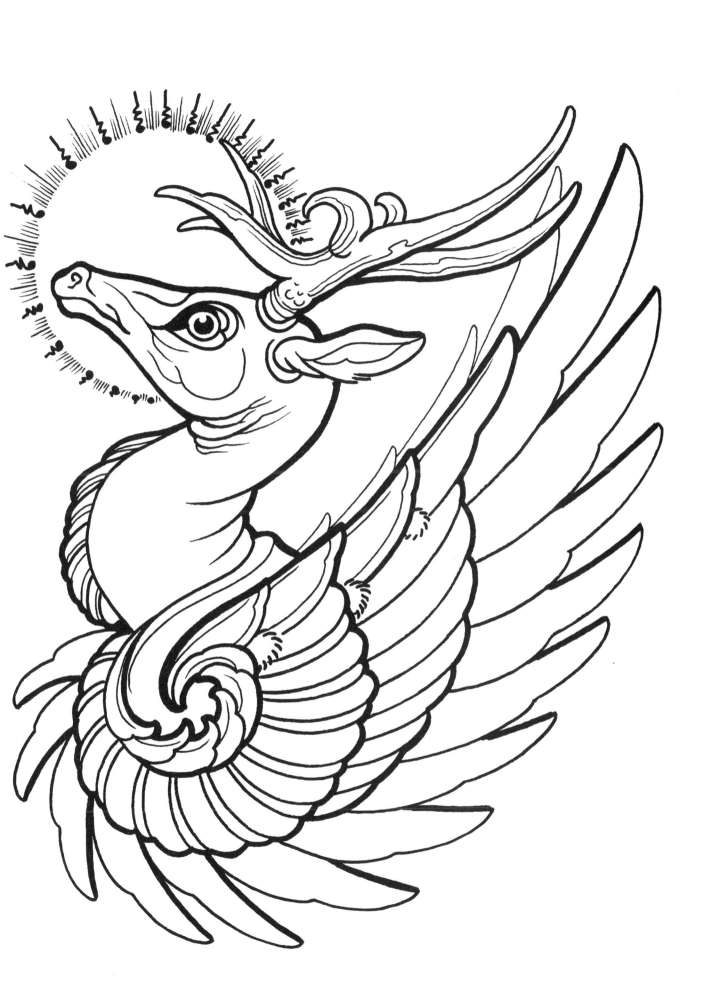

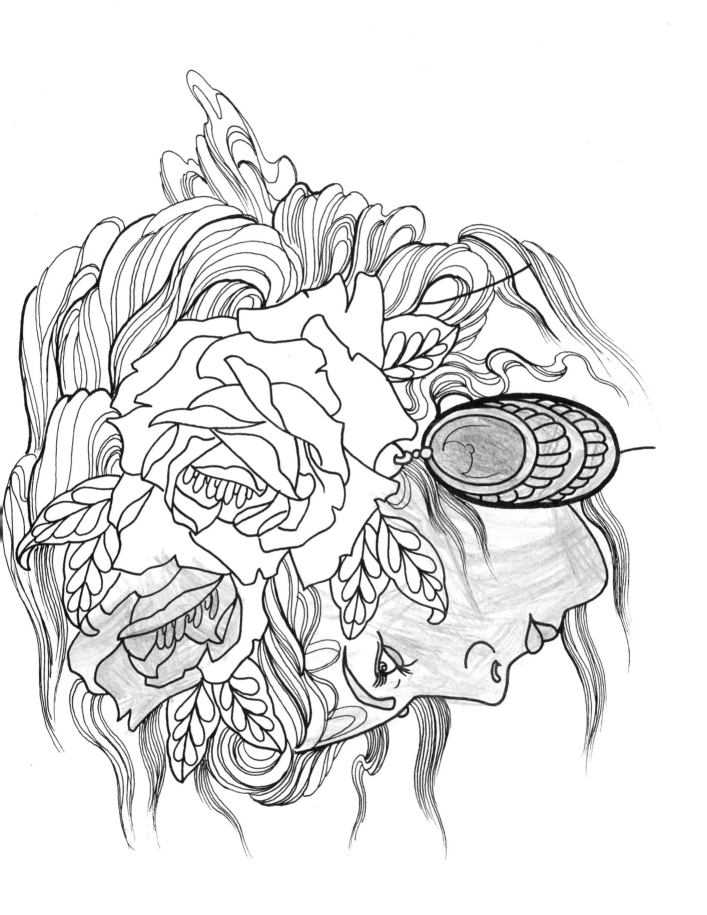

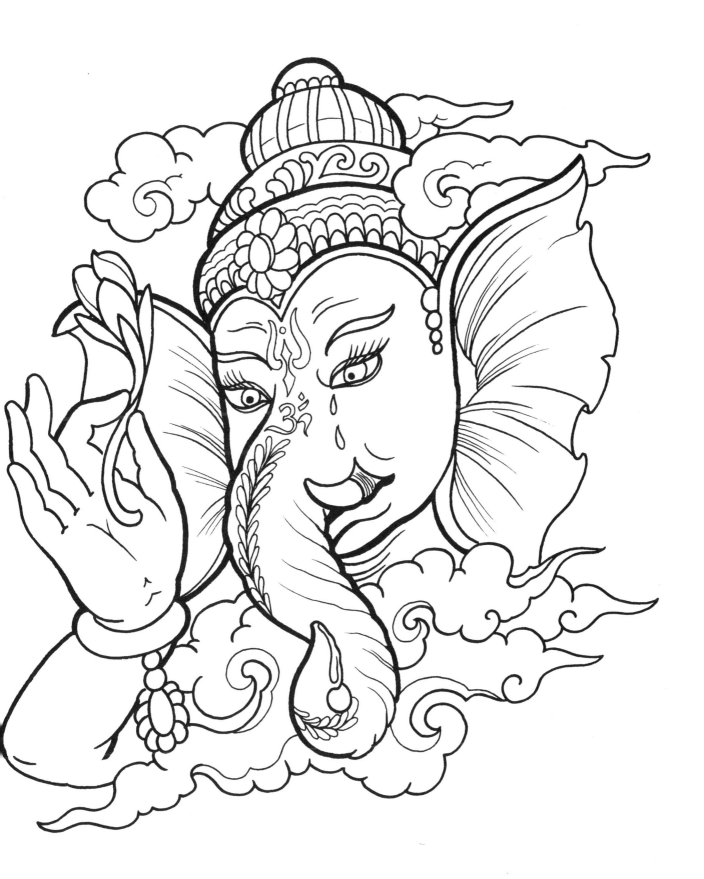

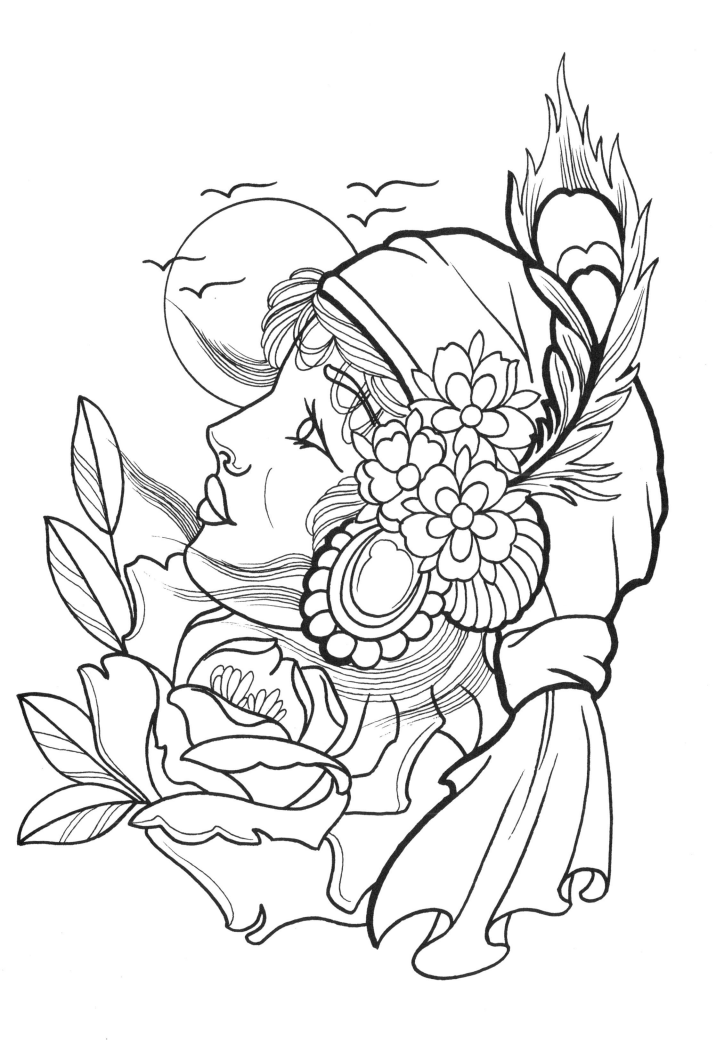

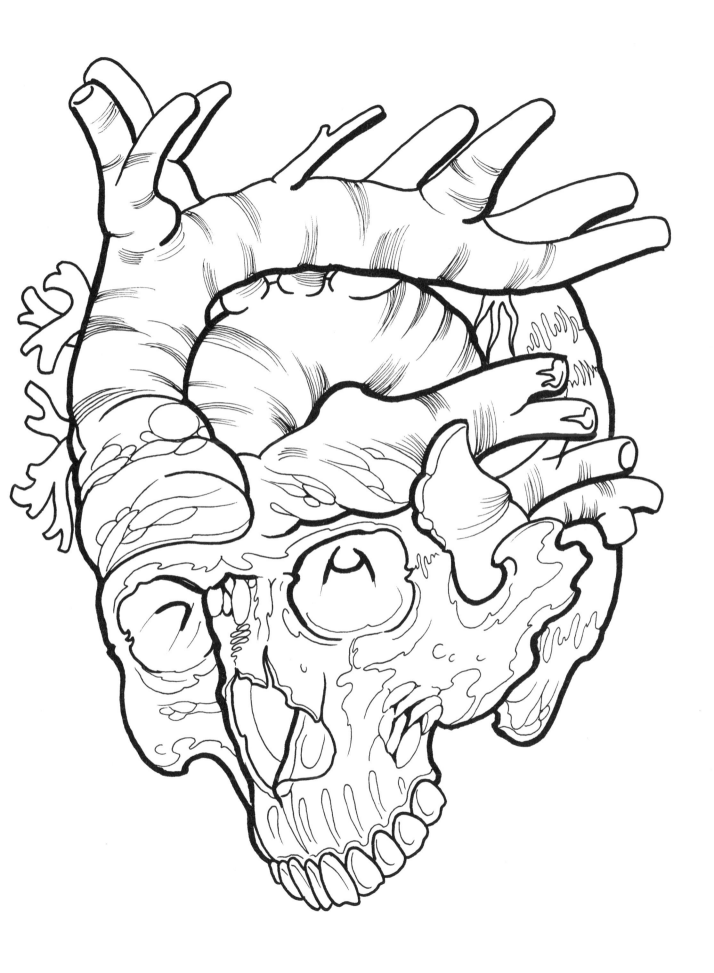

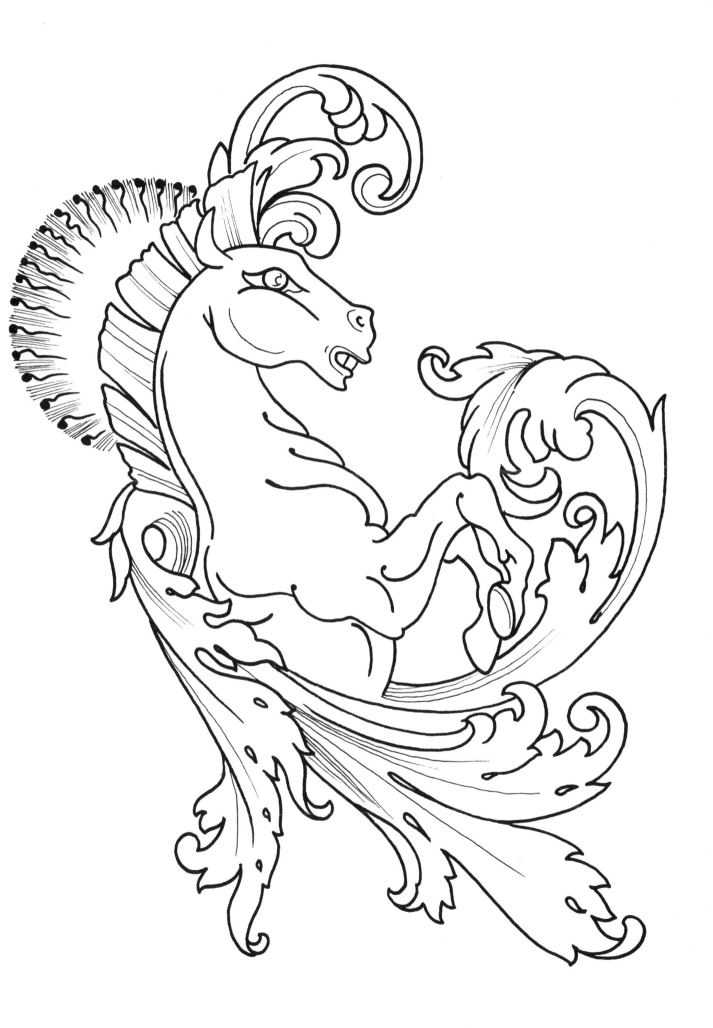

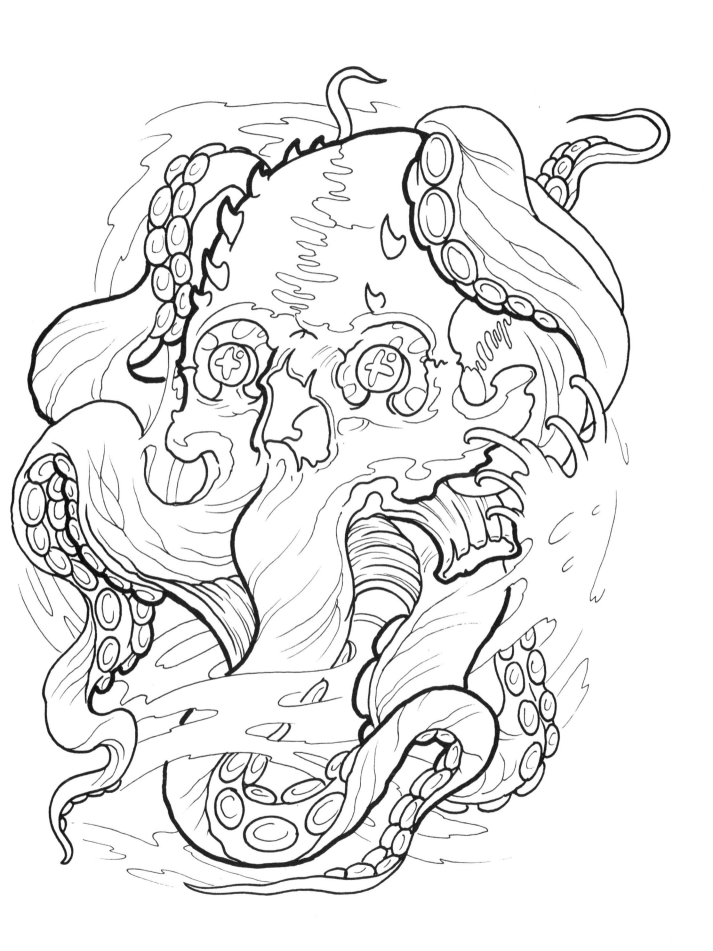

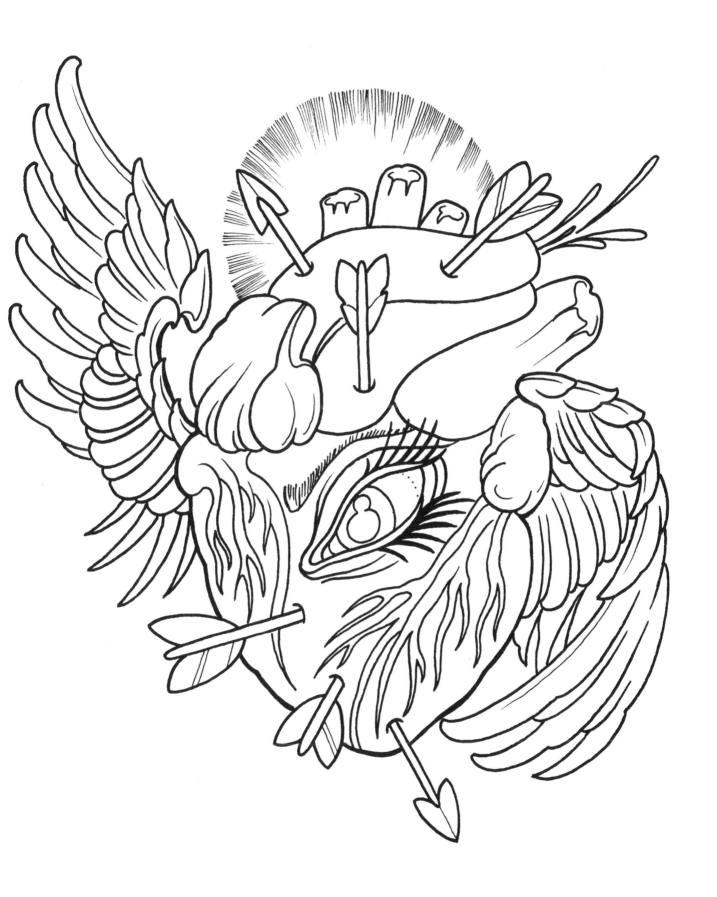

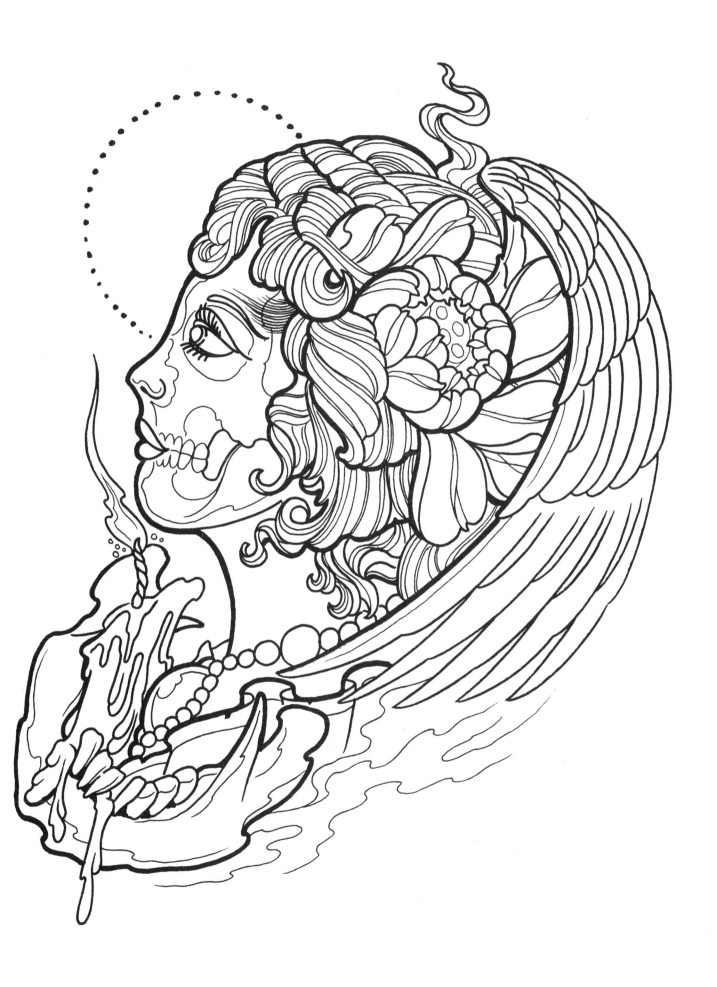

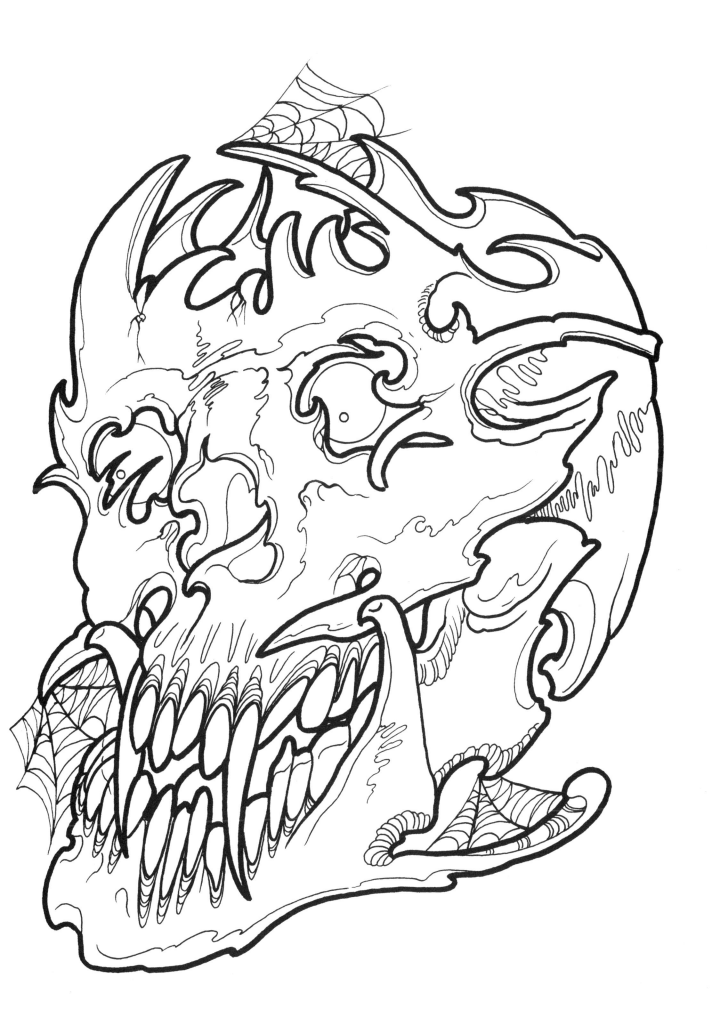

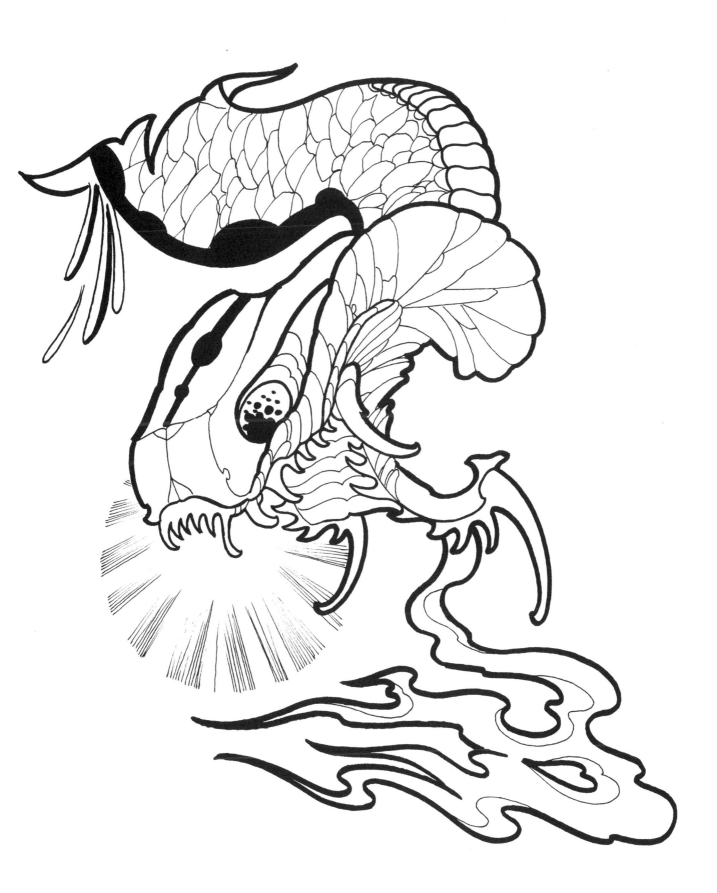

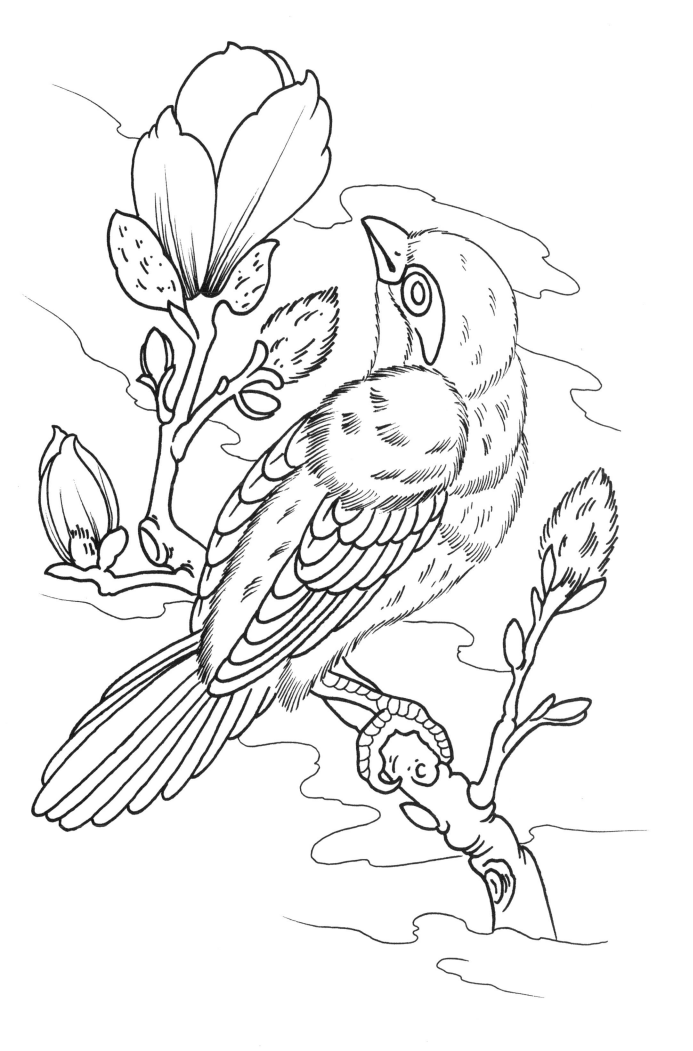

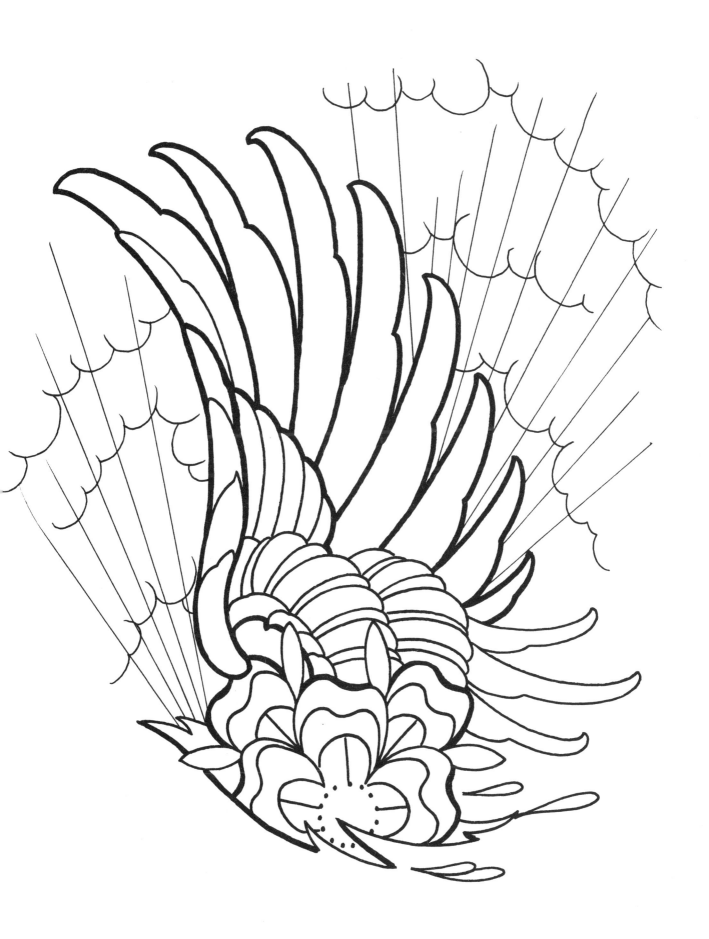

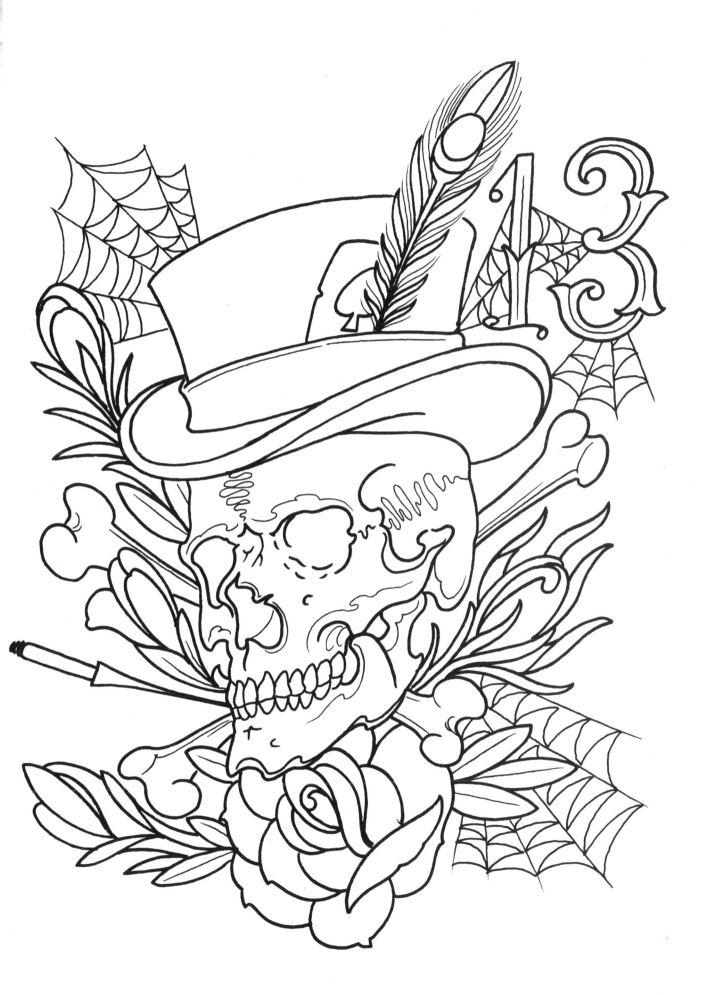

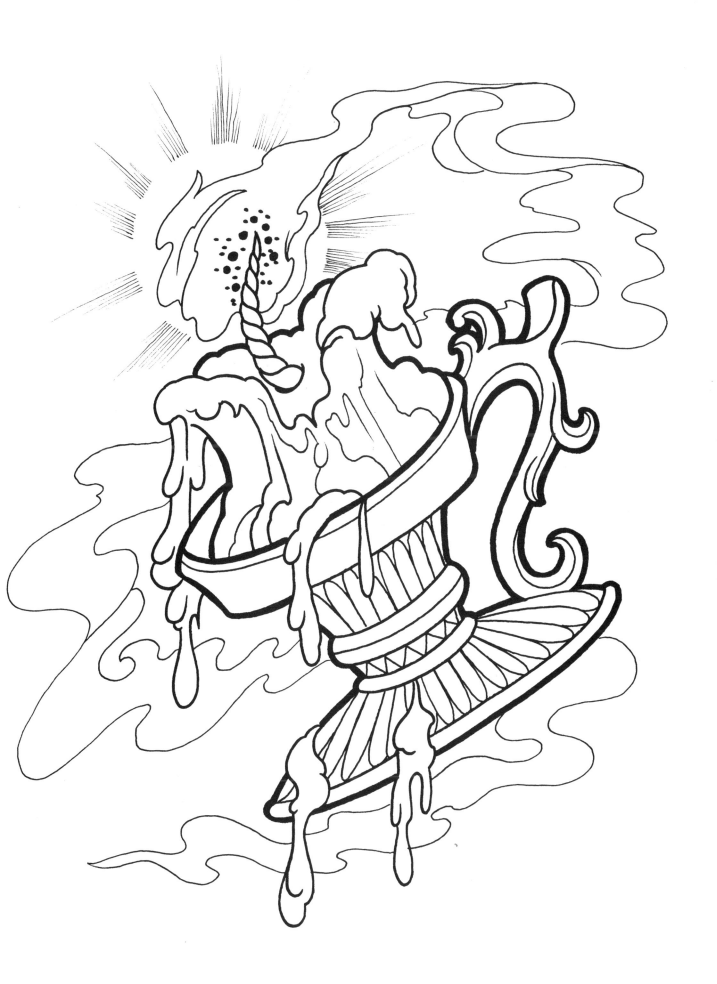

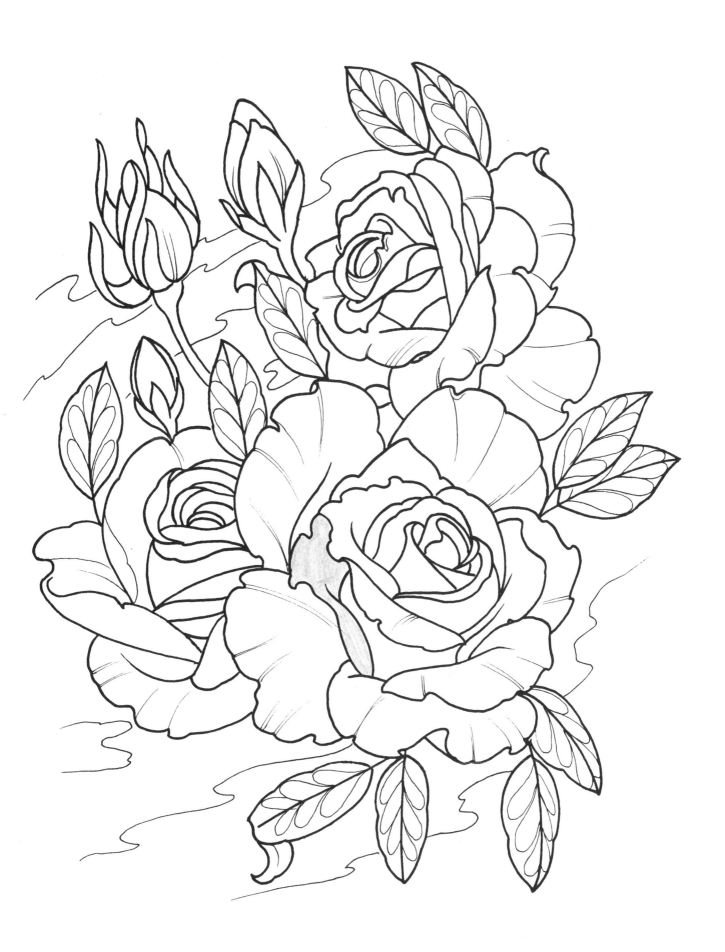

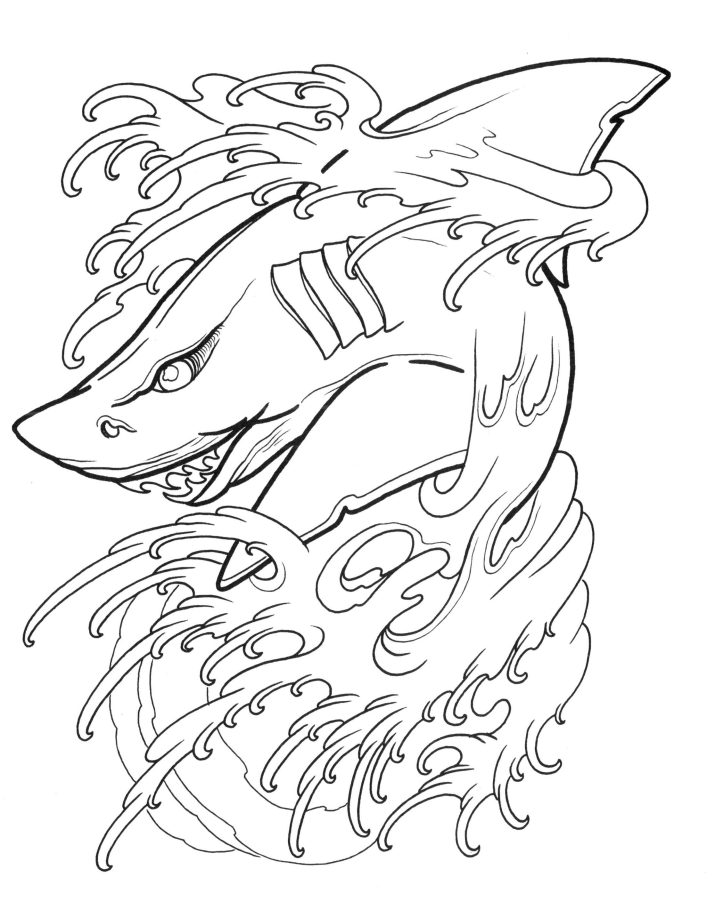